New Photography: San Francisco and the Bay Area

by Thomas H. Garver

The Fine Arts Museums of San Francisco
M. H. de Young Memorial Museum
6 April - 2 June 1974

The Fine Arts Gallery of San Diego
San Diego, California
13 July - 8 September 1974

Catalogue Designed and Produced by Ron Rick
Typesetting by Graphic Arts of Marin
Printed by Phelps/Schaefer, San Francisco
Binding by Cardoza-James, San Francisco

Copyright 1974
The Fine Arts Museums of San Francisco
San Francisco, California

Library of Congress Catalogue
Card Number 74-78134
ISBN 0-88401-002-3

Preface

This exhibition, *New Photography: San Francisco and the Bay Area,* marks the return of exhibitions of contemporoay photography to the M. H. de Young Memorial Museum, after an absence of several years.

In the late 1960's exhibitions of photography at the de Young Museum had proliferated to the point where the medium almost dominated our exhibition schedule. It was decided, in a reevaluation of our exhibition program, to concentrate temporarily on photography exhibitions of more historical interest, which have included Retrospectives of Paul Strand and Minor White, as well as *French Primitive Photography.*

Thomas H. Garver, the museum's Curator of Exhibitions, continues to explore his long involvement with the photographic medium by organizing this exhibition. We extend thanks to him and to The Museum Society for their generous support of the exhibition, as we do also to the National Endowment for the Arts, which has underwritten most of the cost of publishing this catalogue.

This exhibition is an indication of a renewed commitment on the part of The Fine Arts Museums of San Francisco to contemporary photographic expression, a commitment which will evidence itself in periodic exhibitions of the work of the photographers of the Bay Area.

Ian McKibbin White, Director of Museums

Acknowledgements

This exhibition is the product of many individuals and institutions, all of whom warrant acknowledgement and thanks. Certainly I must first thank all of the photographers who took the time to show me their work. I reviewed the portfolios of almost one-hundred and twenty artists and the selection of the twenty-three photographers seen in this exhibition has been a difficult but rewarding experience for me.

The photographers whose work you see here have individually and as a group been most helpful and cooperative in assisting with the assembly of the exhibition, and in compiling biographical information, photographs and other catalogue data. It has been a pleasurable experience to work with them. This catalogue has been made possible by a grant from the National Endowment for the Arts, a federal agency, and The Museum Society.

I would also like to thank Lynda Kefauver, Assistant Curator of Exhibitions and Publications for her research efforts and assembly of biographical material on the artists for this catalogue; Norah McKinney and Norma McNamara for careful preparation of the catalogue manuscript through its many revisions; and Melvyn Sprenger, the museum's Chief Preparator and his staff for their installation of this exhibition.

THG

Introduction

In a recent essay,* which is a long preface to a review of two books of photographs by Walker Evans and Diane Arbus, Susan Sontag (a perceptive and sentient critic of American art and life) takes a highly critical position in reference to the medium of photography. Her comments are worth noting, because her criticisms tend to reiterate those of other observers, such as Marshall McLuhan and Daniel Boorstin, in stating that photography is a mechanical and universal tool which all too often interposes itself between the individual and reality. Recent critics have noted that while photography may serve as a replication of the world, these images really say little about anything, save perhaps the documentation of a surface appearance. As more images are produced and disseminated, we become increasingly inured to them, and our threshold of response to their content rises to desensitize their effect.

Sontag holds that photography levels experience into images, ". . . leaching out the world . . . turning it into a mental object. . . ." She also holds that unlike other, more hand-crafted, flat surface works of art, such as paintings and drawings, ". . . Photographed images do not seem to be statements about the world so much as pieces of it: miniatures of reality that anyone can make or acquire." She does, however, acknowledge that photographs, even of the most precise representational sort, are "as much as interpretation of the world as any other work of art." However, ". . . like every other mass art form, photography is not practiced by most people as art. It is mainly a social rite, a defense against anxiety and a tool of power." Interestingly, she regards photography's "passivity and ubiquity" as the basis of "its aggression," its ability to invade anywhere and dissemble itself into any form.

One senses in Sontag's writing a desire to reestablish a creative hierarchy of visual form-construction. She implies that if a medium is easy on one level, it cannot be perceived on another level as art, or at least as high art; and that universal accessibility to a medium must lead to a degradation of its form. One wonders if her sometimes polemic observations about the ubiquity and protean sensibilities of photography might be transposed across a formal gulf into the medium of language. In her words, we are now "image-junkies", but we have been word-junkies for centuries before the silver image, films, and television restructured our experiences.

Can the photographic image, in its almost complete permeation of conscious and unconscious sensibilities, be more directly compared to words? Words themselves are without morality, identity or expression, acquiring all of those qualities by context and association. Words are usually not used to communicate below the surface of a verbal reality, as most photographs may not penetrate below an abstracted appearance or semblance of visual reality. Sontag says that, "strictly speaking, it is doubtful that a photograph can help us to understand anything. The simple fact of 'rendering' a reality doesn't tell us much about that reality." She seems to deny the possibility that photographic ideas, other than of a surface sort, can be cut from a visual matrix, as literature is assembled from the matrix of words. In so doing, she denies photography the possibility of metaphor, permitting it only a thinning of reality. Artists who are involved with the medium in a creative way (and certainly the artists seen in this exhibition), are less interested in a direct transcription of reality than with forms and symbols which can be abstracted to allow the development of metaphor.

Consider what another writer has said about photography. Working with Walker Evans in assembling the text and photographs for the book *Let Us Now Praise Famous Men*, James Agee wrote most expressively both of the possibility of the inter-relationship of word and image, and how this inter-relationship might be misunderstood.

> The immediate instruments [in the production of the book] are two: the motionless camera, and the printed word. The governing instrument — which is also one of the centers of the subject — is individual, anti-authoritative human consciousness . . .

> The photographs are not illustrative. They, and the text, are coequal, mutually independent, and fully collaborative. By their fewness, and by the impotence of the reader's eye, this will be misunderstood by most of that minority which does not wholly ignore it. In the interests, however, of the history and future of photography, that risk seems irrelevant, and this flat statement necessary.

Can art be cut from ubiquity? It is, of course. Is photography uniquely a "camera vision," to use Walter Chappell's phrase, the product of the black box and sliver paper? Or can it share a larger body of ideas and techniques with other forms of visual art that may make a photograph as a work of art more diffuse in appearance and intent? Photography is, and must be, regarded as a viable art form, for it shares many qualities of mentation and technique with other media; however, it does have certain characteristics that are unique to the medium.

Photography is a new method of visual documentation, but it is the most dominant one, and it is not surprising that it has engendered the most confusion as to its identity and intent.

Photography does deal with reality in a different way. The machine does replace the hand (but not the mind) at the interface between life and art. Our perceptions of photographic images as art are indelibly colored by our perceptions of photography used in other ways, but the photographers who move towards their own fulfillment as artists, work and think much as do artists in other media. Their involvement, no matter how literal their images, is with the

conceptualization, formation and effectuation of ideas in which the issues of art are seen as an ongoing process. Photography-as-Art is one fragment of photography. The segment of the medium called art is not based on any *a priori* requirements as to creative form, but is presented and perceived within a certain contextual framework. Because the medium is such a dissembling one, and because our culture is such a compartmentalized one, photographs as art are presented in places and publications usually reserved for art. We are encouraged, in fact usually required, to go to places of art to see art, no matter what the medium of execution. While the sheer quantity of photographs seen outside the museum's walls may exasercbate the issue of the identification of photography as "art", the medium's universal availability on many levels cannot preclude its aesthetic legitimacy.

Recently, however, the demarcation, usually so visible, between photography and the other art media has begun to diffuse. Artists who document their concepts, their evanescent performances or objects by photographs, or who use photographic images as a portion of a compound work, may or may not be considered photographers. Some individuals trained as photographers have modified their work to the point where it may be included in exhibitions of various media.

This modification of the medium and the shift in the perception of what might constitute camera vision has begun to obscure the definitions of art-photograph and art-photographer, making the role of the critic more difficult. This is worth mention because, while this exhibition is limited to the photographic medium, its intent is more to demonstrate a field of ideas that may be shared by the visual arts rather than an arrangement of aesthetic images. This exhibition focuses on ideational rather than imagistic points of view. If there is any intellectual tie that serves to unite the artists seen here, it might well be a certain obsessive sensibility with which each photographer has pursued his work. Even in the most banal, informal or fluid images, there is an avoidance of expediency. In addition, there is the desire to select and refine one's descriminations, to be sensitive to events within and without one's self, but not to respond only to an imagery motivated simply by existential events.

At the onset of the organization of this exhibition I had assumed — from ignorance — that there would be a relatively clear-cut point of view to be found in Bay Area photography. I was mistaken. There is no single "high style" to be found here, and one cannot will it so. Artists, after all, determine the nature of art, although one might say that in this medium, as with the rest of the visual arts, San Francisco and the Bay Area look within. There is a consciousness here that makes one look backward as one moves forward. One proceeds to new work, with an awareness of history, of photographs and photographers of the recent and far past. In matters of aesthetics, while Los Angeles or New York seeks a more specifically defined position in the *avant garde,* this area seems to "make haste slowly."

*The New York Review of Books. 20, No. 16 (Oct. 18, 1973).

Descriptive Catalogue of the Exhibition

Most of the photographs in this exhibition are untitled. Each separate image relates so closely to the body of photographs exhibited by each artist, that a traditional catalogue checklist would serve little purpose. These brief outlines of the photographer's work, prepared by the author of this catalogue, are intended as a description of the nature of the photographs rather than an attempt to identify a number of single images.

Crawford Barton has been photographing homosexual life in San Francisco for the past several years. His photographs document the private lives of homosexuals and public events where the "gay" and "straight" societies interface with one another.

Ellen Brooks *Bread Spreads*, exhibited here, is composed of three units, each approximately ten feet high by eight feet wide. The first two units are compound images of bread, printed on small squares of photo-sensitized canvas and stitched together. The third unit, described by the artist as a "celestial field" of crumbled bread, is printed as a single image on a large piece of fabric.

Nacio Jan Brown has photographed street life on a single block of Telegraph Avenue in Berkeley over the last several years. The portraits of young people exhibited here have been excerpted from a large group of work, all documenting the block, which has been assembled for publication.

Robert Brown has responded to the use of the camera as a device for making images by using it to make "non images." He expands a single image to become both a field and environment, photographing walls which are replicated full-scale photographically and used to form the actual sides of a room. The work in this exhibition is a closed space, sixteen feet square, lined with a surface of photographic paper printed with concrete blocks.

S. E. Ciriclio assembles photographic records of evanescent events and projects in other media, which she has created into scrap books which are both documents of past occurrences and independent visual objects in themselves.

C. Curtis Corlew has recorded the night life of Main Street in Walnut Creek. It is a life of display and demonstration, of high powered cars, suggested sexual availability and swaggering *machismo*.

James Friedman combines two aesthetic sensibilities in his photographs. His more traditional single images, such as *Family portrait without my brother, Dan,* tend toward the surreal. More frequently, Friedman works with images assembled to suggest literary or theatrical situations and events. The prints are treated in an expressionistic manner — often fogged, chemically-colored, unevenly developed or otherwise manipulated after the photographic image is produced.

Kenneth Graves has been documenting high school football teams, not to record their athletic prowess, but rather to illustrate involvement with "the team" as one of those socializing rites of passage into adulthood.

Ronald Greenberg working as photographer, etcher and silk-screen printer, has reshaped images photographed in abandoned army buildings on Angel Island, by using them as the basis for photographically produced etchings and silkscreen prints. These prints are produced directly from the photograph, although he may rework certain passages of an image by hand after it has been transferred to the plate or screen.

Glenn Harrison uses photographs as a basis for the development of a visual and literary fantasy world. The photograph, frequently of the most banal sort, is re-formed by being integrated with verbal fragments, rather like isolated frames from a comic book, in which image and text work as incomplete threads of a story, and made all the more intriguing by its truncated brevity.

Paul Kohl has been involved with photographic still life, objects which may be inanimate or growing, but without inner articulation or motion. A sense of portent, of momentary change within a fixed and unchangeable order, pervade his work, which is further heightened by his concentration on luminosity and texture rather than detail.

Jacqueline Leventhal has photographed one of the Bay Area's largest flea markets, selecting and abstracting certain forms and shapes from the incredible array of objects and individuals she has found at these bazaars. More recently, she has involved herself in photographing the male figure, treating it in the same spare and abstract manner used on the flea market subjects.

William Messer, like several other photographers included in this exhibition, uses photography in a diaristic and metaphorical way, recording the events of his life as though keeping a personal journal. Within that concept he metaphorizes visually, connecting single images of disparate, philosophical or thematic content into compound series with emphasize certain visual similarties and relationships.

Frank Nakagawa has been photographing his mother, chronically ill, whose life is confined to her bed and to the tiny environment of the family's home.

Ira Nowinski has documented the Yerba Buena district, a portion of the city which San Francisco has been trying to redevelop, changing its character by total demolition from a threadbare but viable area of old hotels, wholesale and retail business firms, and light manufacturing concerns, into a convention center, stadium and hotel complex. Nowinski has documented the people who live in the area, the places where they live, and their stiff resistance to being displaced.

Bill Owens is best known for his book *Suburbia,* an unemotional look at residential life of the suburban town of Livermore, California. More recently, he has been concentrating on the appearance and pursuits of suburban organizations and institutions, formal and informal, including city government, fraternal groups, high school sports, youth organizations, as well as bachelor parties and beauty contests. This material will appear in a forthcoming book.

Leslie Poliak uses the camera's capacity to both record and suggest. Her work, concentrating on images of younger people, recall the paintings of Balthus, in which the figures are innocent in appearance yet the composition is heavy with suggestion of erotic portent and fantasy.

Richard Roberts works with chemical and light effects possible only with photographic paper and manipulates the final print to shift qualities of light, space and surface texture. Recently he has been making photograms. Working directly with very large size photographic paper, he places figures and objects on its surface and exposes it to light sources which are moved across the paper to control exposure and vary outlines.

Susan Shaw in her series of photographs *Romantic Notations* deals "with the minutiae and melodies which are so much a part of romance but are not always apparent." She has executed the series in color ". . . because its soft-hue saturation expresses the mood of true romance and love."

Edmund Shea gave himself a party, inviting perhaps five-hundred friends. As they entered the hall where the party was held he photographed them. He also photographed the guests and entertainers as he moved through the room. For him it was a "portrait of myself" without his image, a portrait seen in his friends and their activities, and transmuted by him into a photographic environment, and printed on photo-sensitized soft vinyl.

Steve Smith is another photographer who uses photographs as a visual journal, recording his passage through time and space. The images linked one to the other like a frozen movie are best seen as relating to a single whole rather than as isolated bits of information.

Gary Stewart uses light as his chief subject matter. In Stewart's photographs light tends to dissolve structure and substance, even architecture into a unifying, softening radiance.

Lew Thomas has drawn his photographic imagery from language and other intellectually oriented constructs which are primarily non-visual. They are documents of intellectual position and are devices for determining the nature and process of the artist's thinking.

Crawford Barton

Born 1943, Resaca, Georgia. Studied at the University of Georgia, Valdosta State University (Georgia), and the Atlanta School of Art. Exhibited at the Atlanta Arts Festival in 1969. Lives in San Francisco.

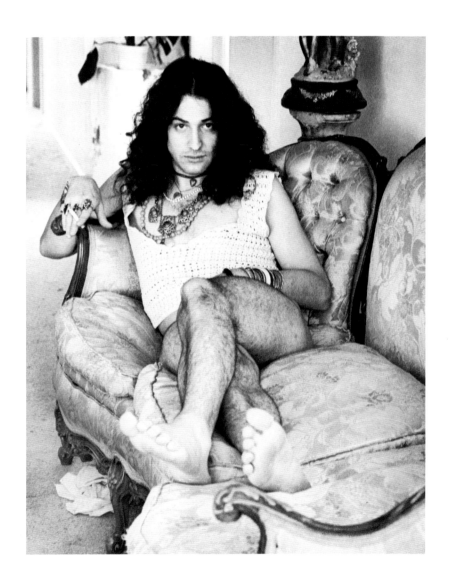

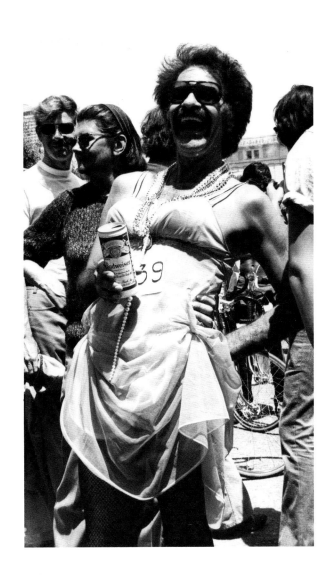

Crawford Barton

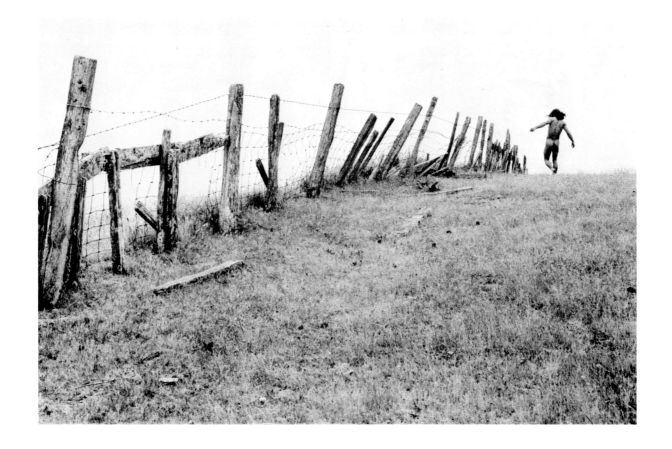

Ellen Brooks

Born 1946, Los Angeles. Studied at the University of Wisconsin and the University of California, Los Angeles. Has taught at the San Francisco Art Institute, University of California Extensions in Berkeley and Los Angeles. Exhibited in numerous group shows, including a two-woman show at the San Francisco Art Institute, "Photography into Sculpture" at the Museum of Modern Art (New York). Photographs published in *Artweek* and *Arts Canada, Arts in Virginia*. Lives in Inverness.

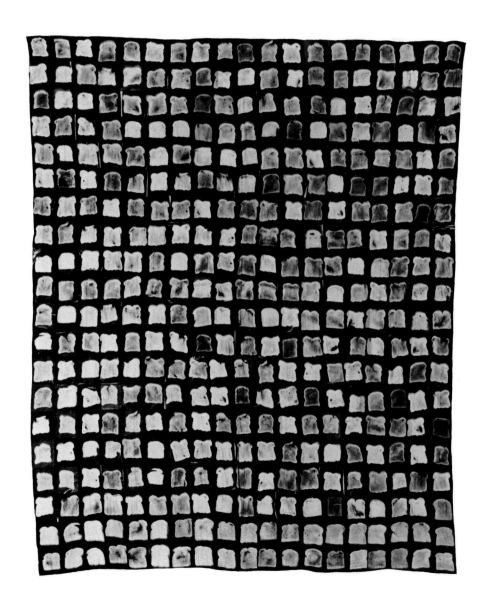

Ellen Brooks

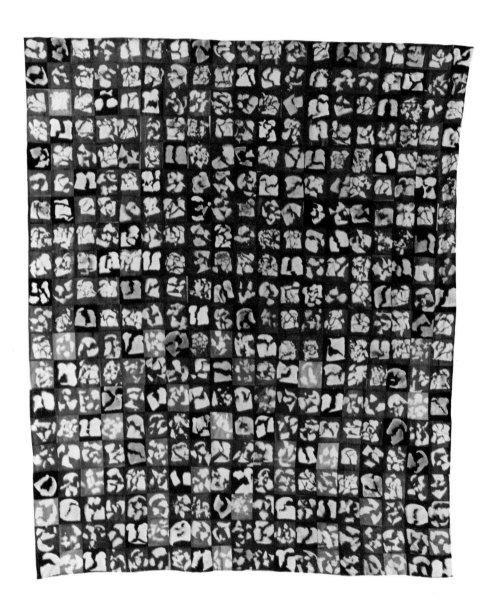

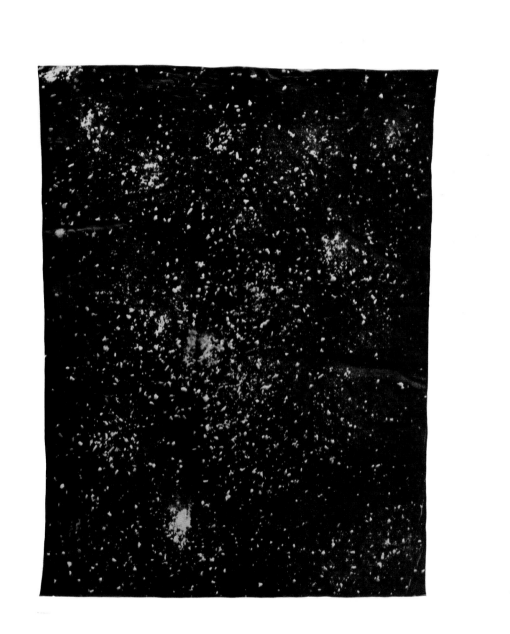

Nacio Jan Brown

Born 1943, Los Angeles. Self-taught as a photographer. Staff photographer for the *San Francisco Express Times* (later, the *Good Times*). Lives in Berkeley.

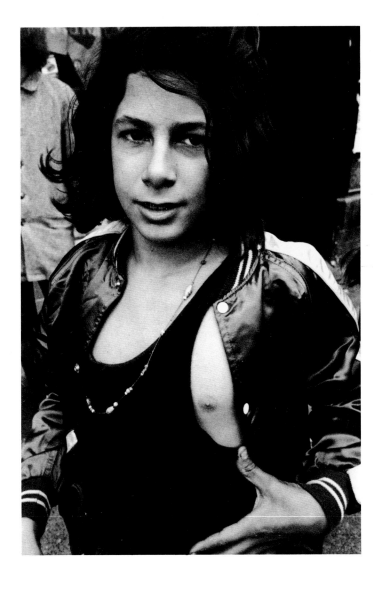

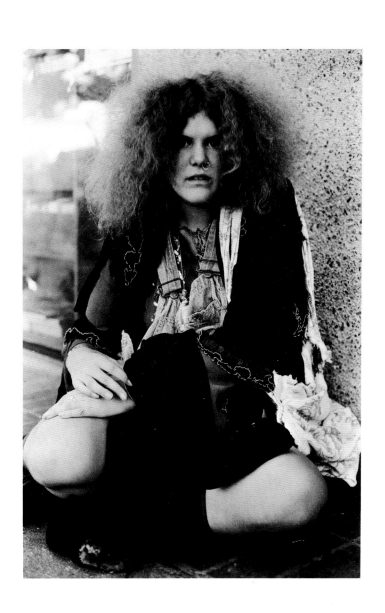

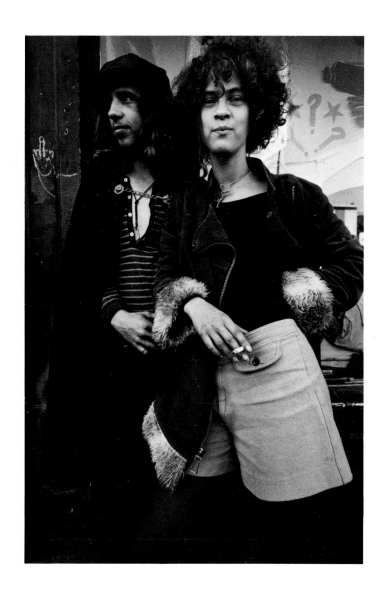

Robert E. Brown

Born 1937, Grouverheur, New York. Studied at Rochester Institute of Technology (New York), California State Universtiy, San Francisco, and the San Francisco Art Institute. He has taught widely in California colleges. One-man exhibitions at George Eastman House (Rochester, New York), Camera Work Gallery (Costa Mesa, California), and California State Universtiy at San Francisco. He has exhibited in numerous group shows. His book *Daisies Daisies Daisies Daisies* was published in 1970. His photographs have been extensively published. Lives in San Francisco.

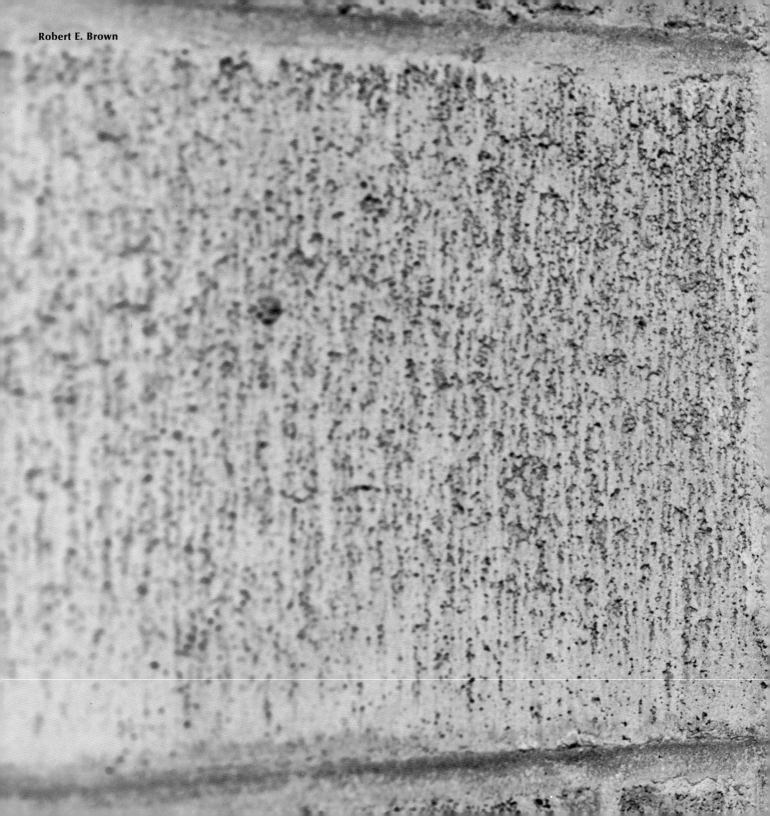

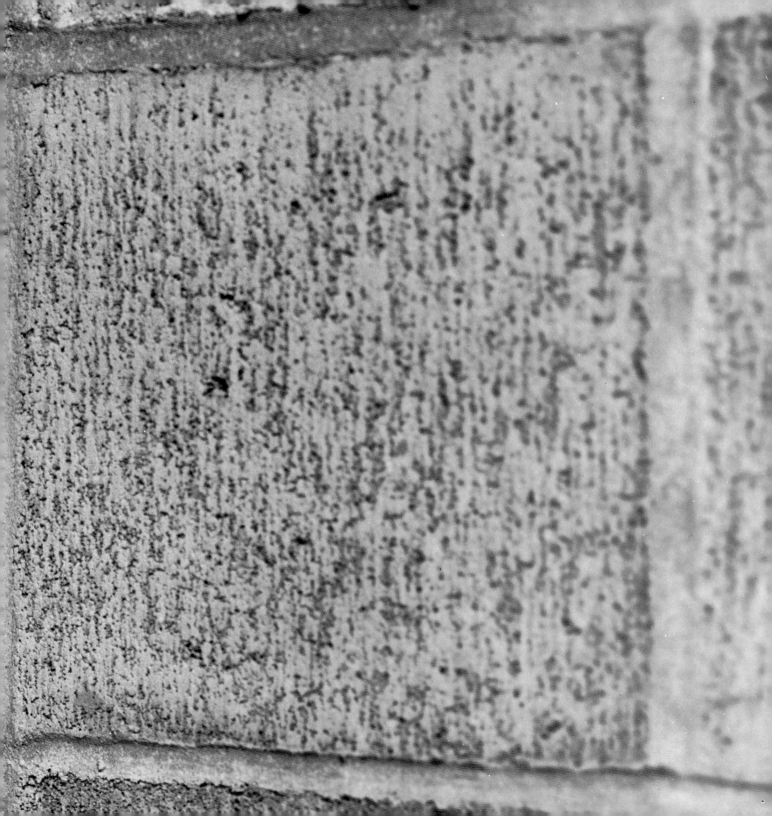

James C. Friedman

Born 1950, Columbus, Ohio. Studied at Ohio State University, Massachusetts Institute of Technology and presently at California State University, San Francisco. One-man exhibition at the Photogenesis Gallery (Columbus, Ohio), and in several group exhibitions. Lives in Berkeley.

Cambridge, Mass., 1972

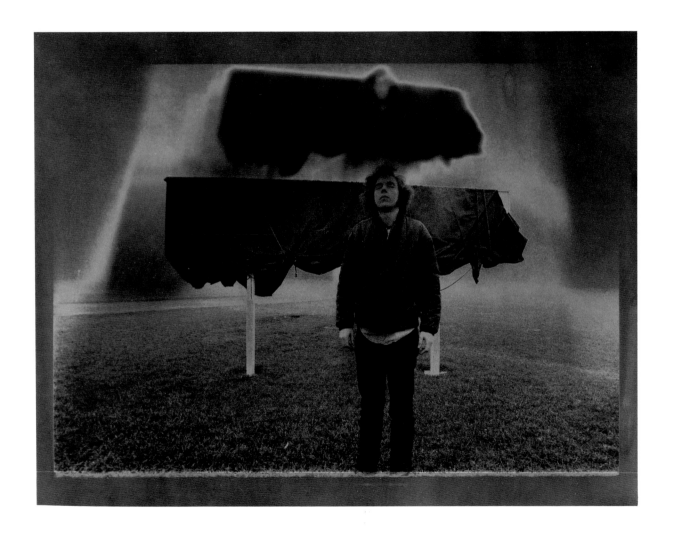

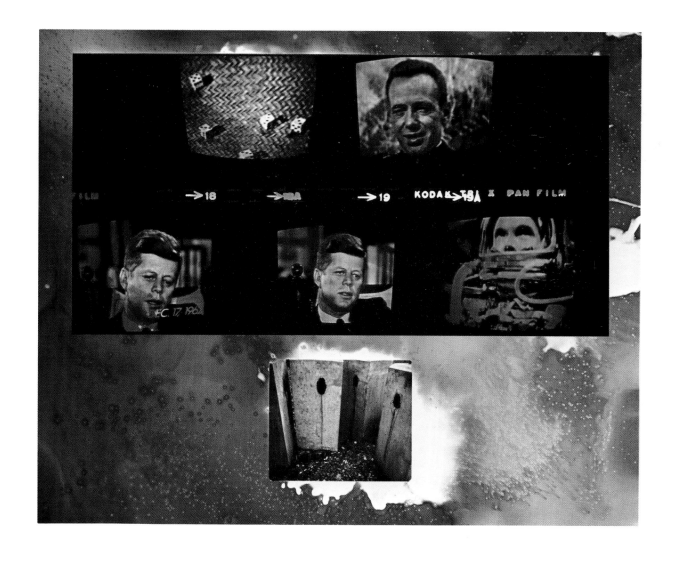

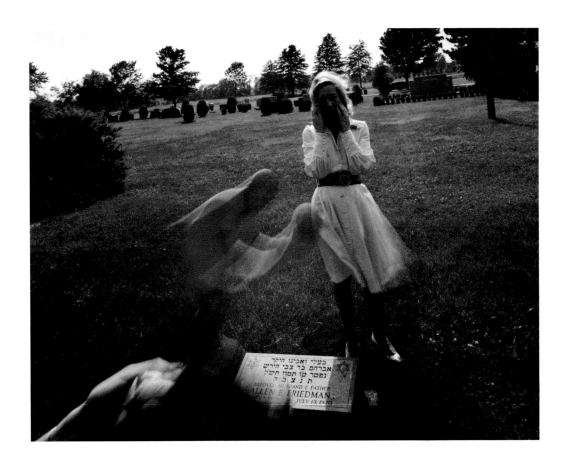

S. E. Ciriclio

Born 1946, New York City. Studied at the California College of Arts and Crafts, Oakland, and Mills College, Oakland. Presently teaches at Chabot College in Hayward. Exhibited at the Phoenix Art Museum (Arizona), the Oakland Museum and The San Francisco Arts Festival. Lives in Oakland.

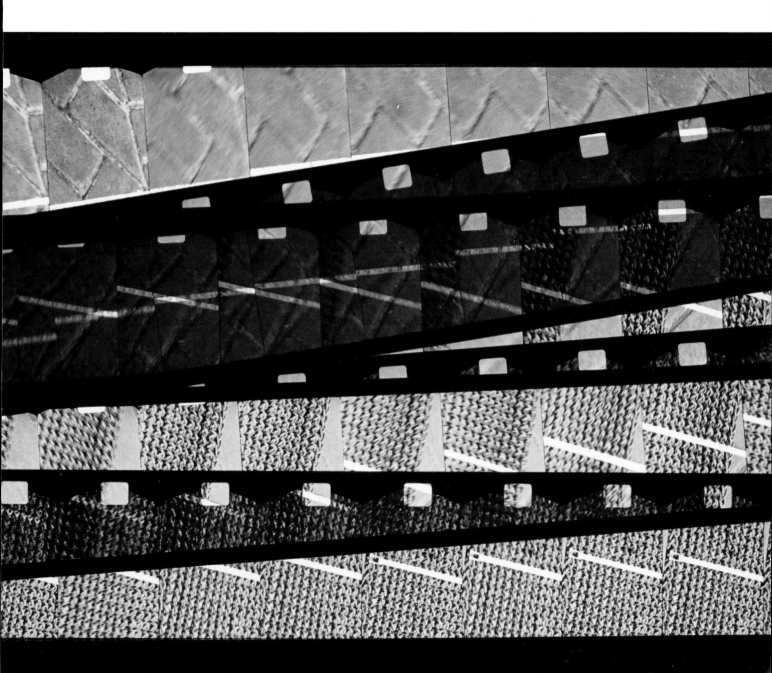

-S. E. Ciriclio

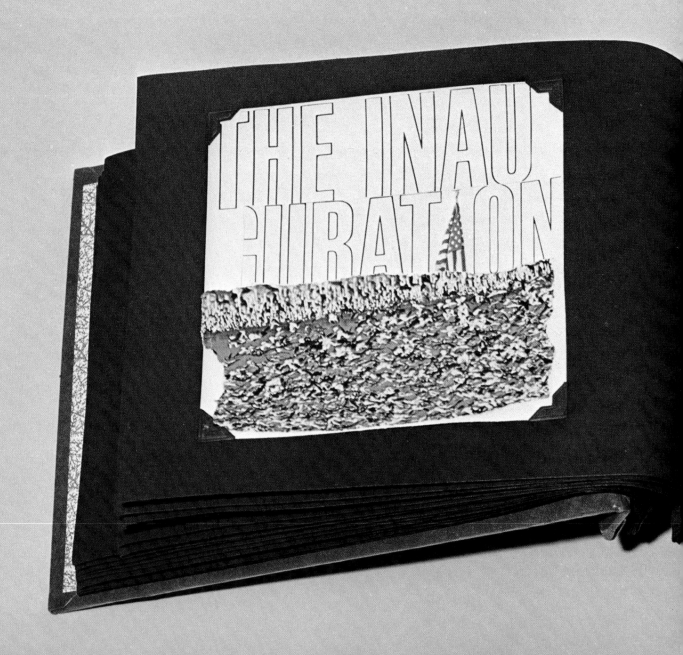

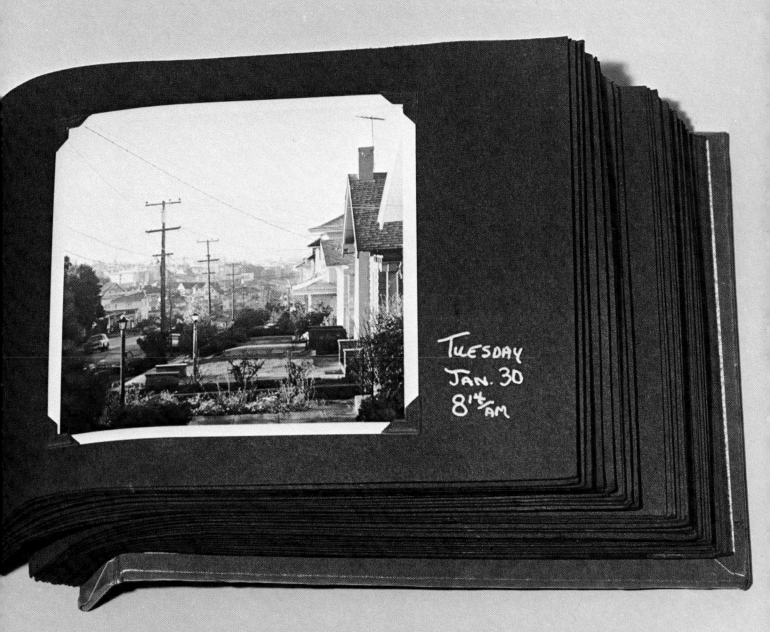

Tuesday
Jan. 30
8¹⁴/AM

Susan Shaw

Born 1951, Jersey City, New Jersey. Studied at the University of California in Santa Barbara and the San Francisco Art Institute. Exhibited at the Gazebo Gallery (San Francisco) and the San Francisco Art Institute. Lives in San Francisco.

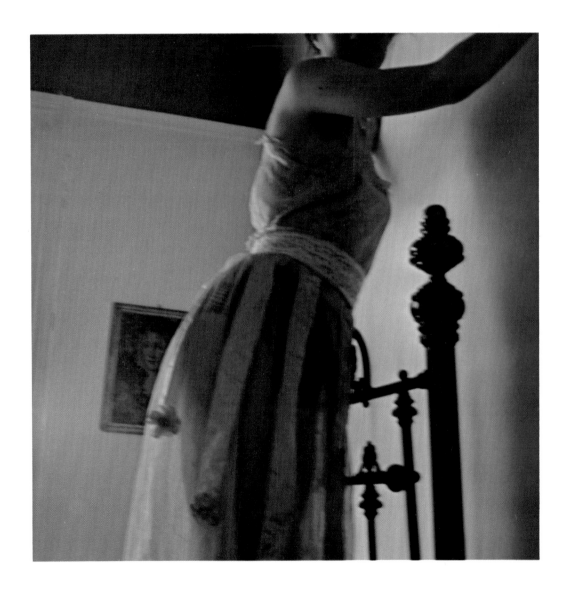

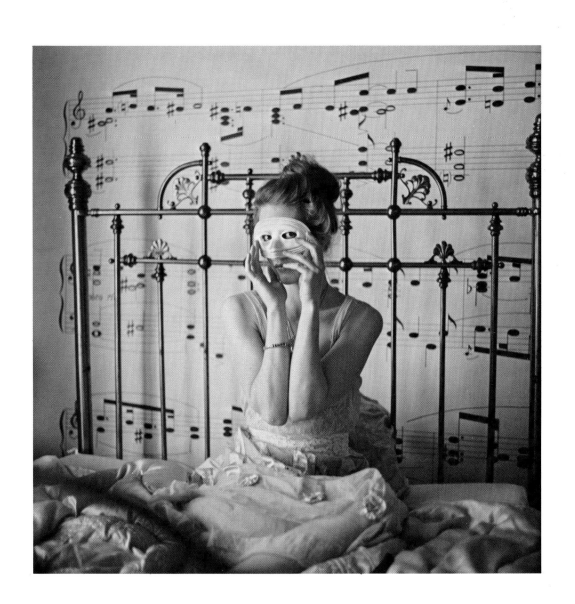

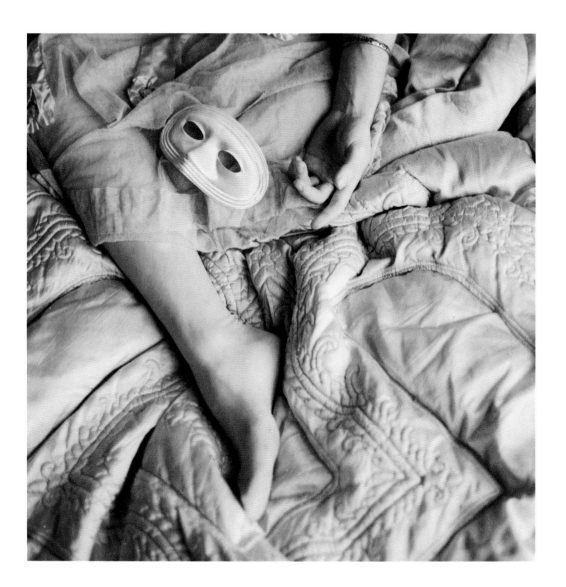

Richard Roberts

Born 1936, Douglass, Arizona. Studied at the University of California at Los Angeles and the San Francisco Art Institute. Exhibited at the Oakland Museum and Long Island University (New York). His photographs to be published by Eastman Kodak in a book entitled *Experimental Photography*. Lives in Berkeley.

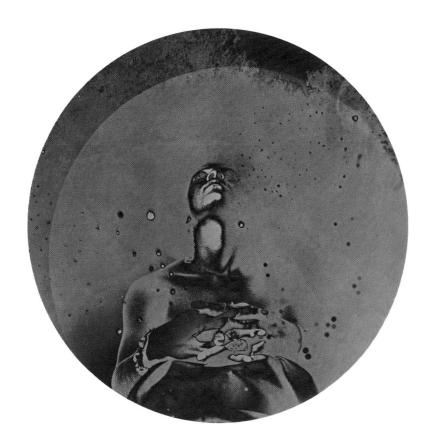

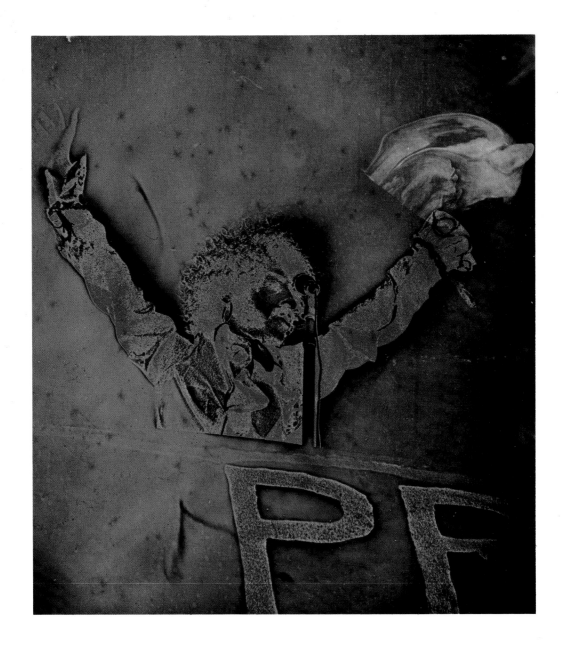

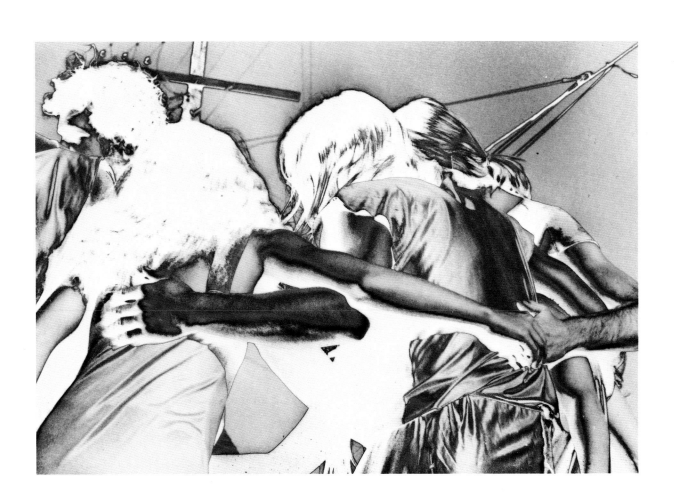

C. Curtis Corlew

Born 1953, Fresno, California. Studied at Diablo Valley College and presently at California State University, San Francisco. Exhibited at the University of Korea in Seoul. Member of the photographic group "Garden for the Blind." Lives in Walnut Creek.

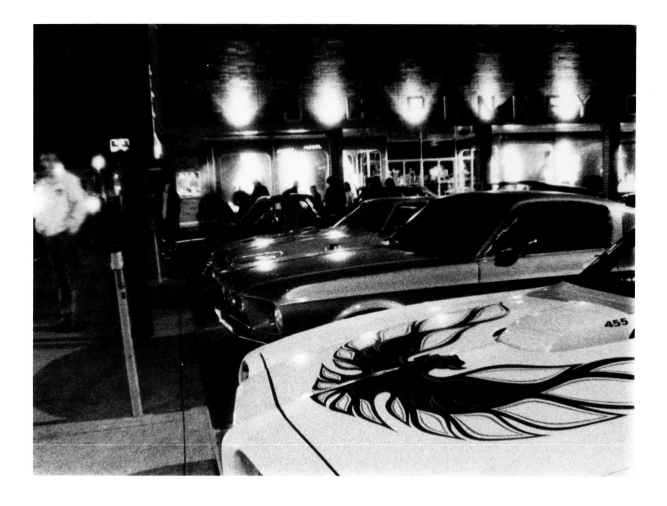

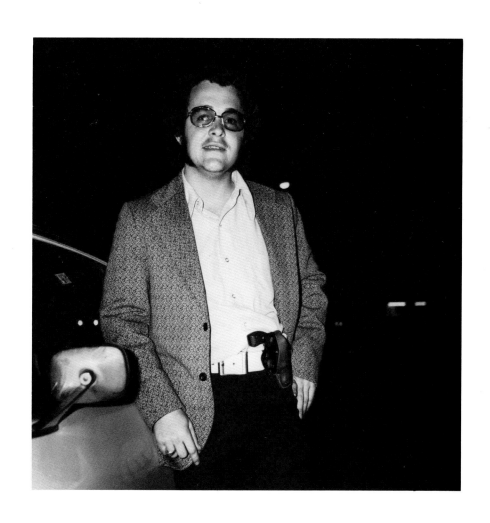

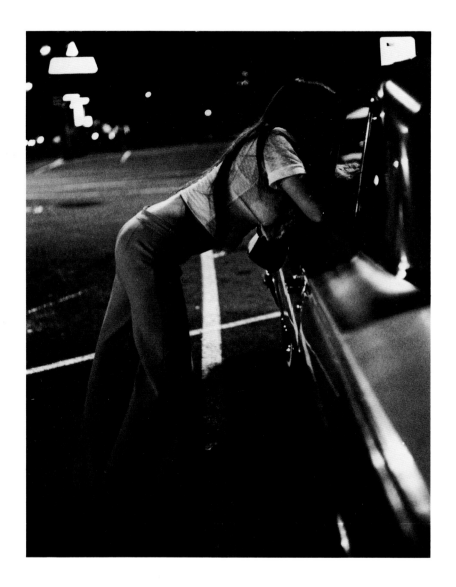

Kenneth Graves

Born 1942, San Jose, California. Studied at the San Francisco Art Institute. Exhibited at the San Francisco Museum of Art, the San Francisco Art Institute, the Massachusetts Institute of Technology and the Focus Gallery (San Francisco). Photographs published in *San Francisco Camera, Camera, Ramparts,* and *Rolling Stone.* Received the Ferguson Grant in 1974 from the Friends of Photography (Carmel). Lives in San Francisco.

Defensive back, George Washington High Eagles

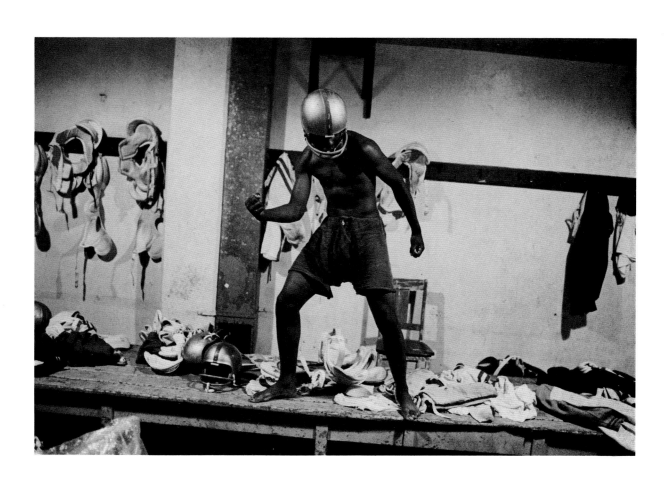

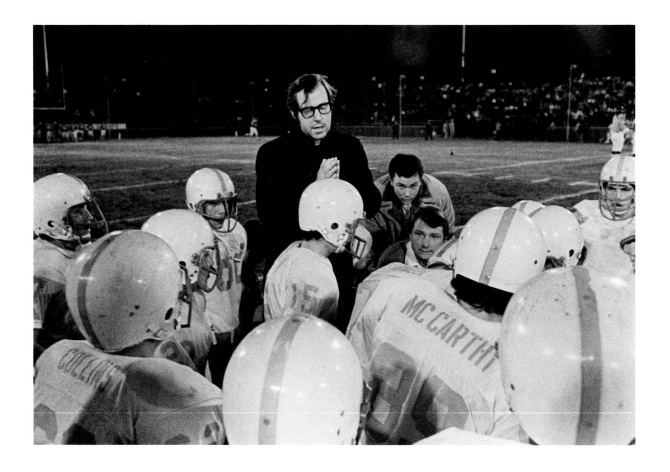

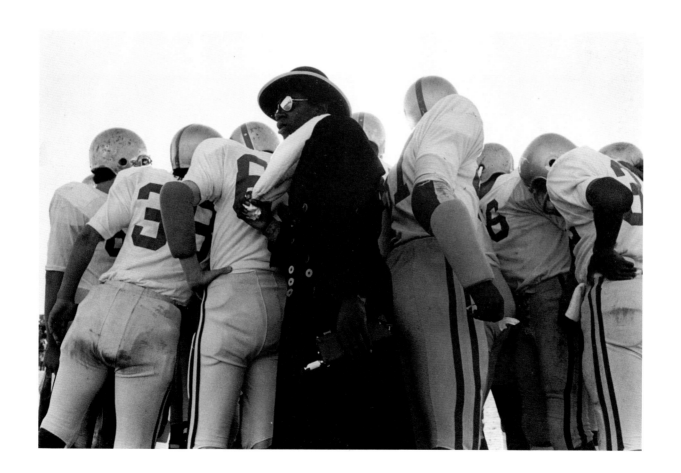

Ronald J. Greenberg

Born 1947, Brooklyn, New York. Currently studies at the San Francisco Art Institute. Participation in group exhibitions at the San Francisco Museum of Art, Capricorn Asunder Gallery (San Francisco) and the San Francisco Art Institute. Worked at Crown Point Press in Oakland. Lives in San Francisco.

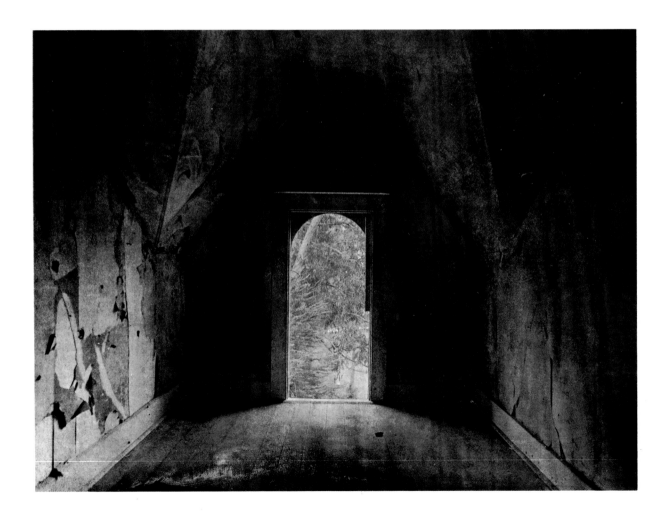

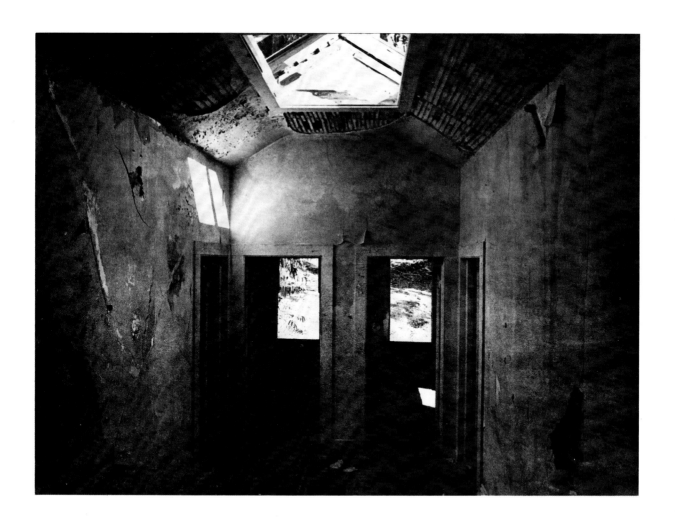

Ronald J. Greenberg

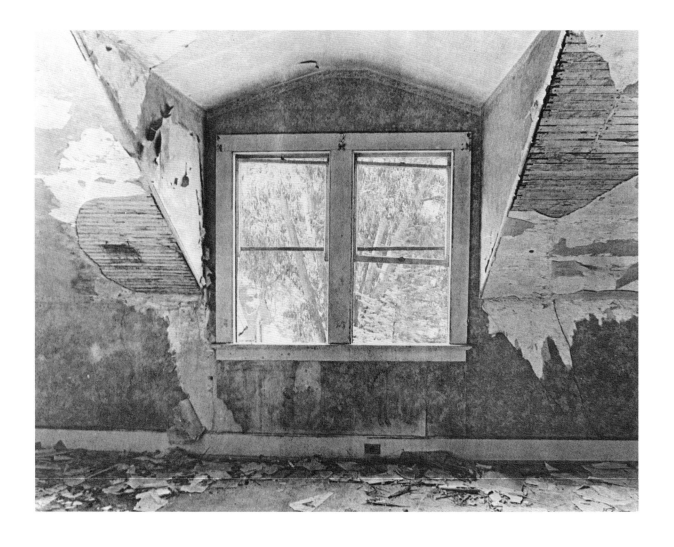

Glenn Harrison

Born 1944, Houston, Texas. Studied at the University of Missouri and the San Francisco Art Institute. Exhibited at the University of California at Davis. Lives in San Francisco.

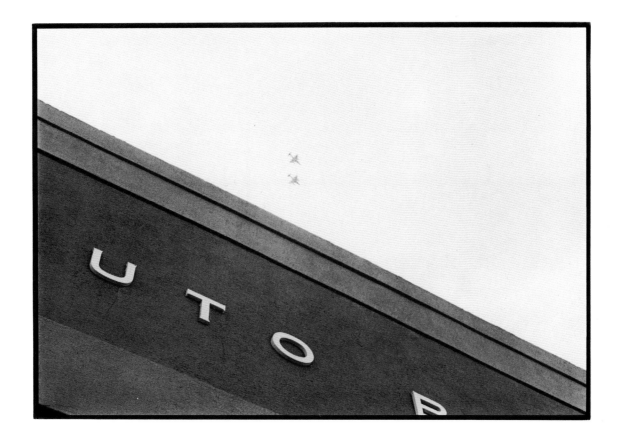

Two jets screamed towards a nearby target beginning the daily bombing of Uto Pea as she stepped off the train and entered the main station. She had come back to her factory job in the city after several days in her old village. Planes had been seen there only once when a dyke was destroyed and some of the fields were flooded. The station would be safe as no railroads or harbors or military bases other than anti-aircraft batteries and fighter fields were attacked. The usual targets were people's homes and hospitals and schools. The enemy had absolute control of the air and chose to make a terror war upon the people of Uto Pea but never the government and army. She should turn around and take the train right back to her village she thought. It was certainly madness to stay here even one day more.

Glenn Harrison

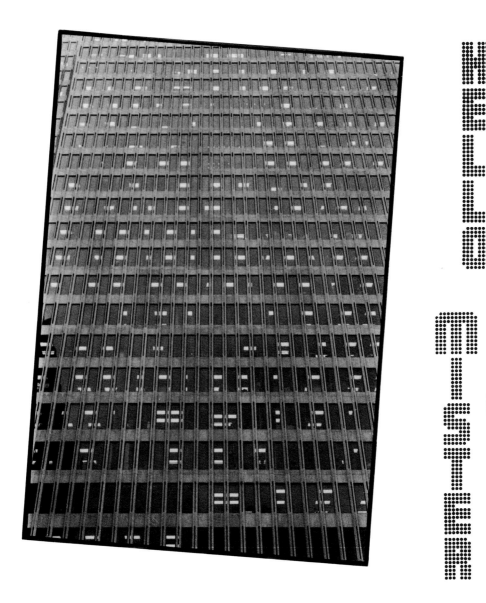

HELLO

DISPLAY

my friend fred from the country and i were walking aroun downtown looking at the bldgs and i sed to him - fred
you know these bldgs remind me of coral reefs - each bldg like a coral and the city like a reef - both communities
built by little animals - polyps and people - both submerged - one in water and the other in air - one got tides
and the other weather what?? sed fred ... and i sed all excited - the bldgs-cities is different than corals
cause polyps- i mean people can move aroun whereas the people- i mean polyps can't and the bldgs-cities have
phones and lights all wired together and and and ...good grief - sed fred - livin in the city so long has rotted
your brain... and you know what else i sed - out on guam where we usta skin dive they got these starfish called
the crown of thorns that's eatin the reefs right up and pretty soon the island will
just wash away... sounds like a five legged caterpillar
tractor to me - sed fred.

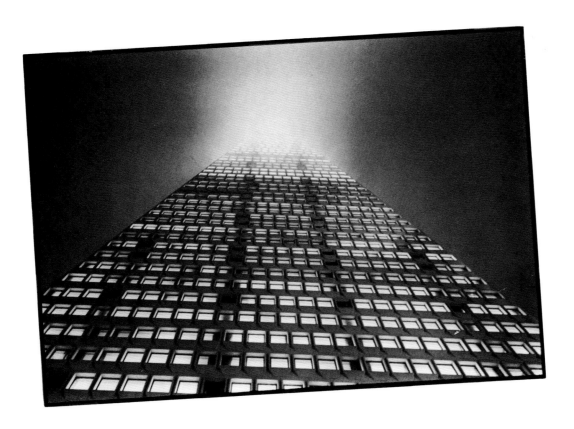

Paul Kohl

Born 1942, St. Louis, Missouri. Studied at the San Francisco Art Institute. Lives in San Francisco.

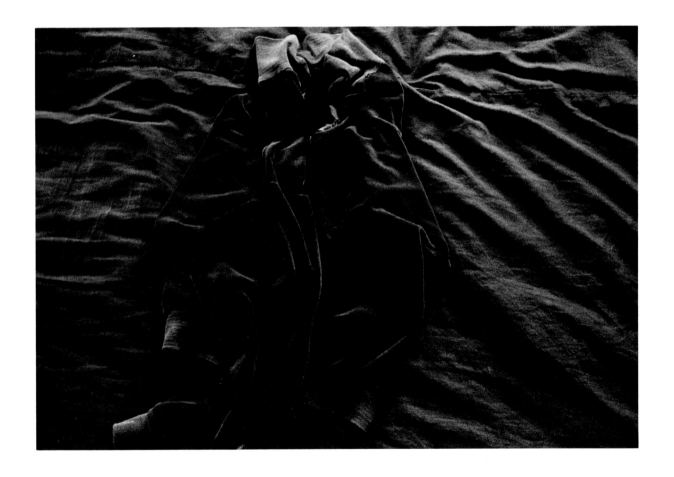

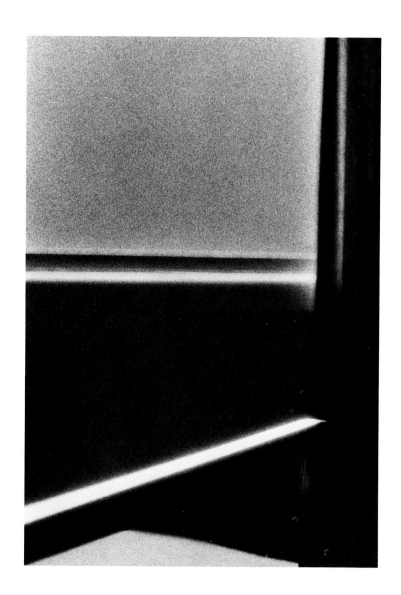

Paul Kohl

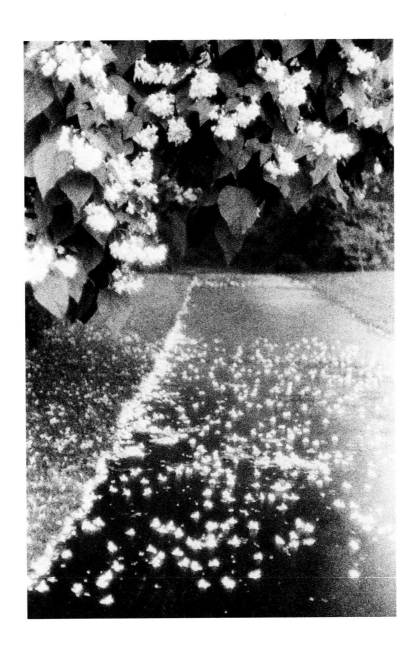

Jacqueline Leventhal

Born in Los Angeles. Studied at the University of California in Berkeley and Los Angeles. Exhibited in group shows at the Walnut Creek Civic Arts Gallery, the San Francisco Art Institute and California State University at Hayward. Lives in Berkeley.

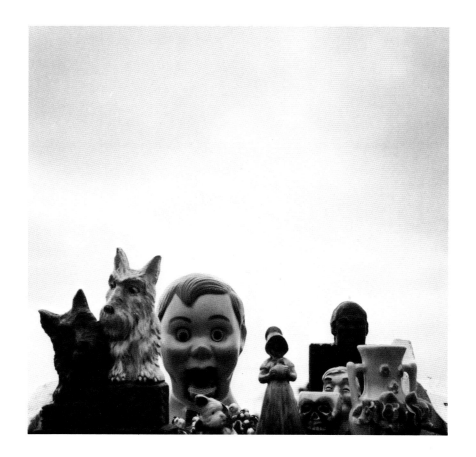

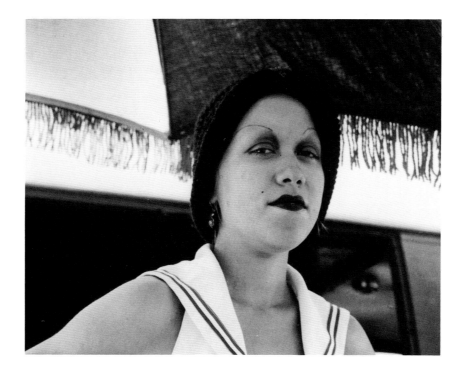

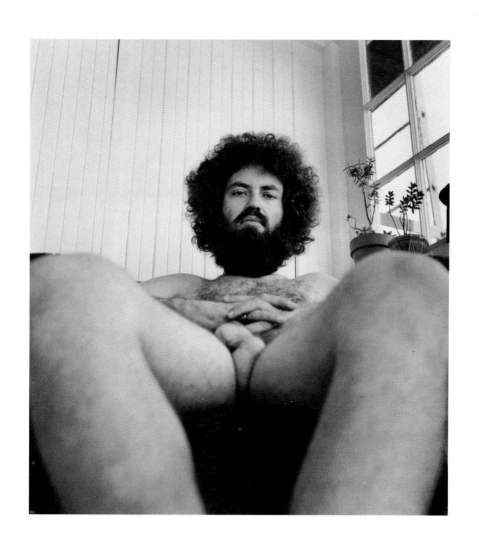

William Messer

Born 1948, Cincinnati, Ohio. Studied at Tufts University and the San Francisco Art Institute. One-man exhibitions at Tufts University, the San Francisco Art Institute, Camera Work Gallery (Costa Mesa, California) and Contemporary Arts Center (Cincinnati). Also exhibited in several group shows. Photographs published in *Terra Photographic Quarterly*, *Creative Camera*, *Camera*, and *British Journal of Photography*. Lectured on photography at the Royal Photographic Society in London and several colleges in Great Britain. Lives in San Francisco.

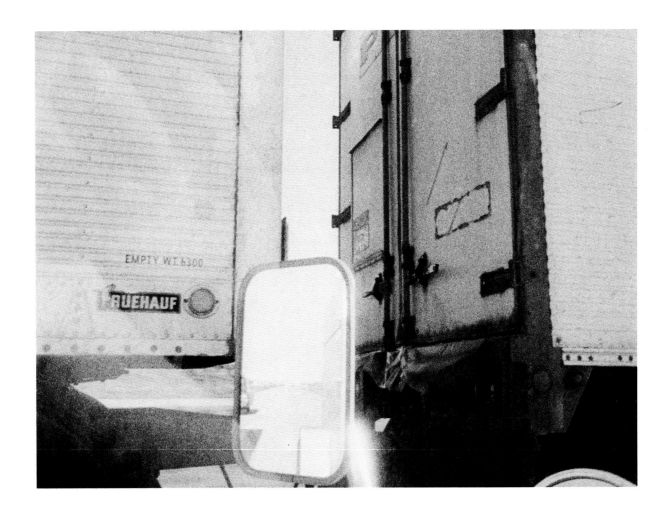

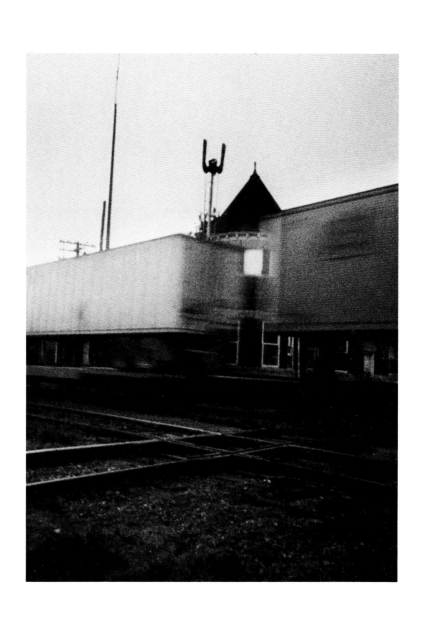

William Messer

Frank Nakagawa

Born 1941, Watsonville, California. Studied at San Jose City College, and is currently studying at the San Francisco Art Institute. Lives in San Francisco.

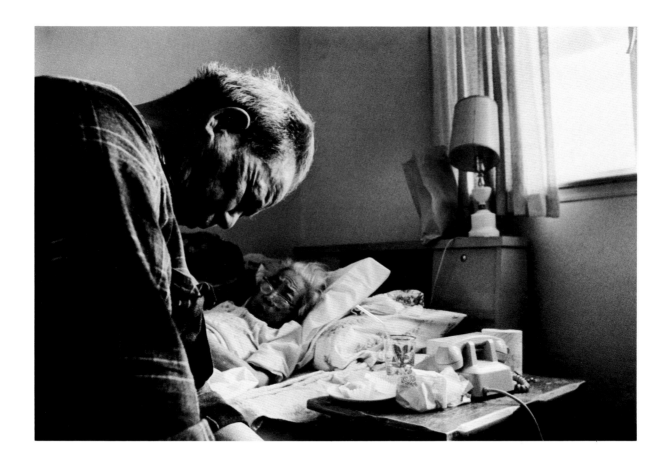

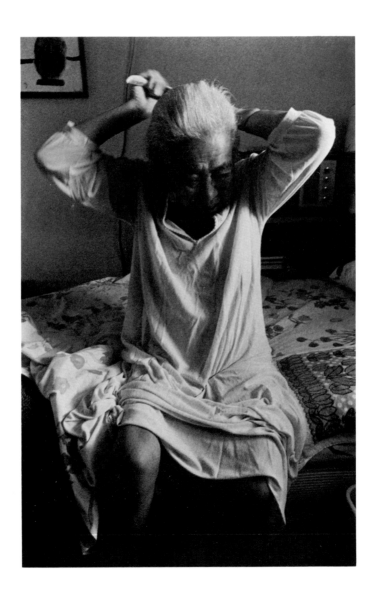

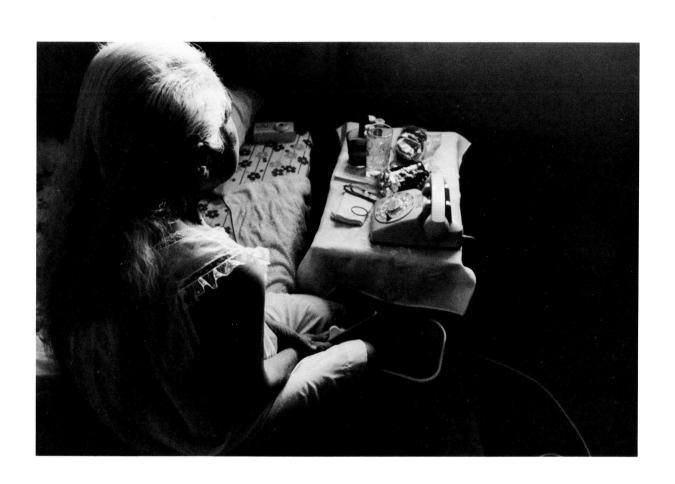

Ira Nowinski

Born 1942, New York City. Studied at the San Francisco Art Institute. Exhibited at Photon West (Berkeley) and the San Francisco Art Institute. Photographs for a book on the Yerba Buena project and an anthology which includes some of his work entitled *Crusading Photography* scheduled for publication in 1974. Lives in San Francisco.

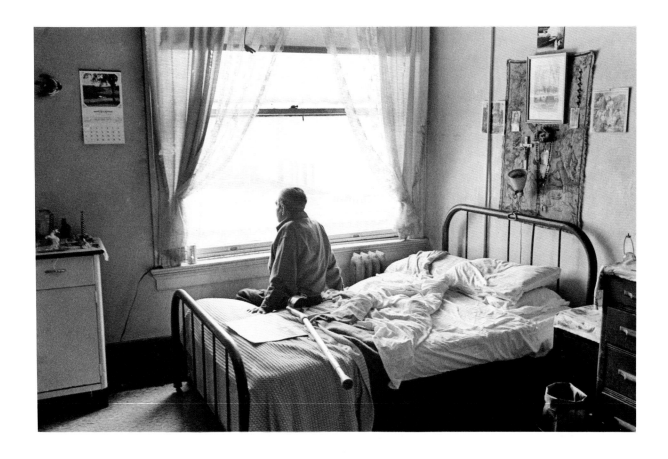

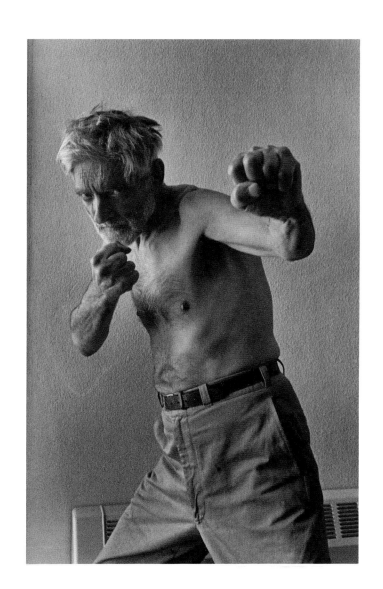

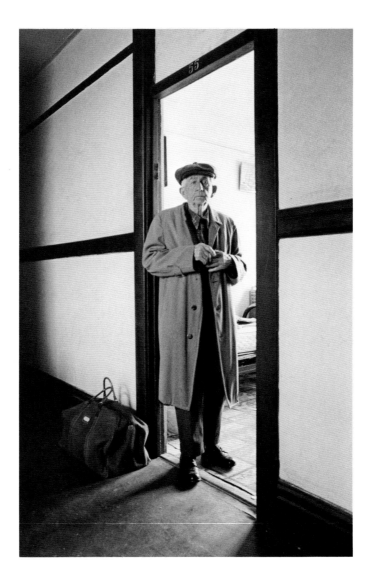

Bill Owens

Born 1938, San Jose, California. Self-taught as a photographer. Exhibited at the Oakland Museum. His book *Surburbia* was published in 1973, and a book dealing with the institutions and rituals of suburbia is in process. Photographs published in *Camera 35, California Living, Life,* and *Esquire.* He works for the *Livermore Independent* newspaper. Lives in Livermore.

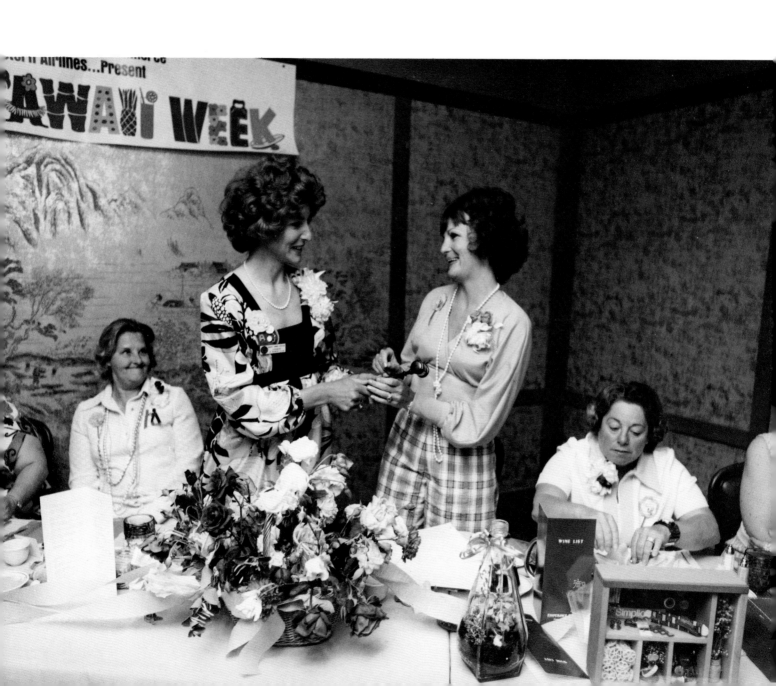

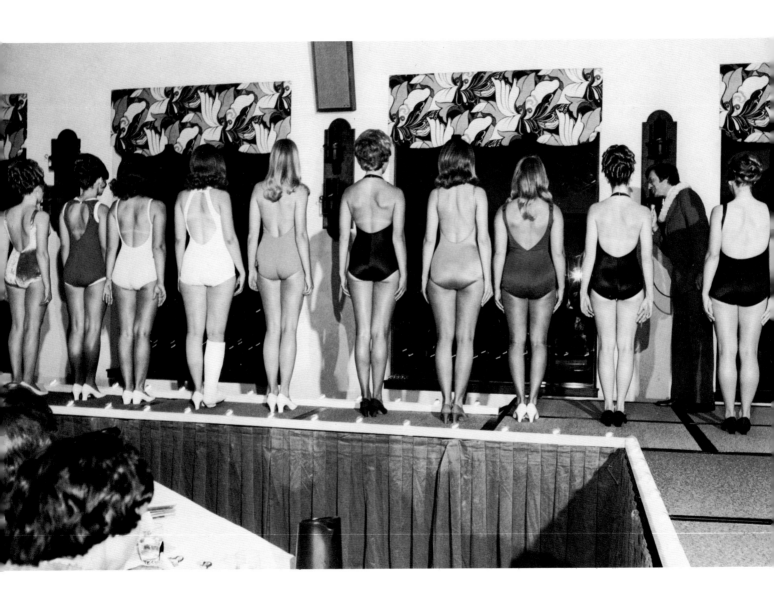

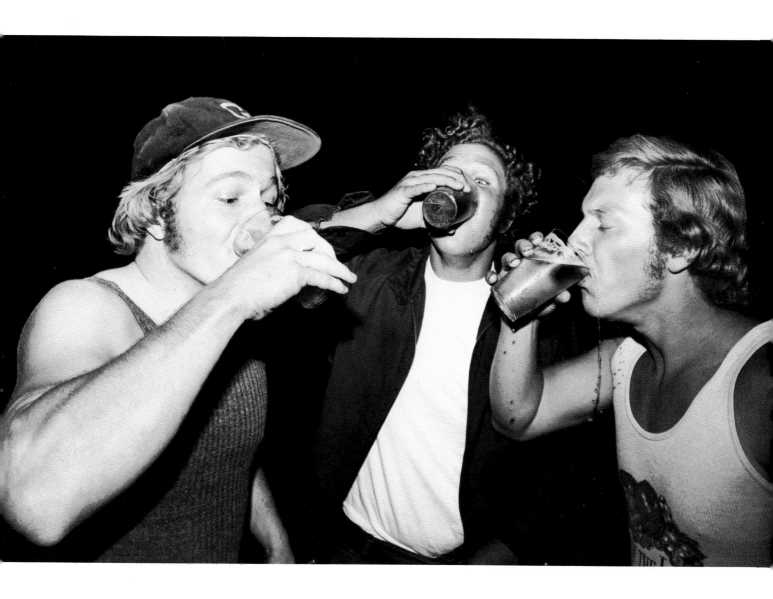

Leslie Poliak

Born 1949, New Rochelle, New York. Studied at the University of Cincinnati, Harvard University Extension and the San Francisco Art Institute. Lives in San Francisco.

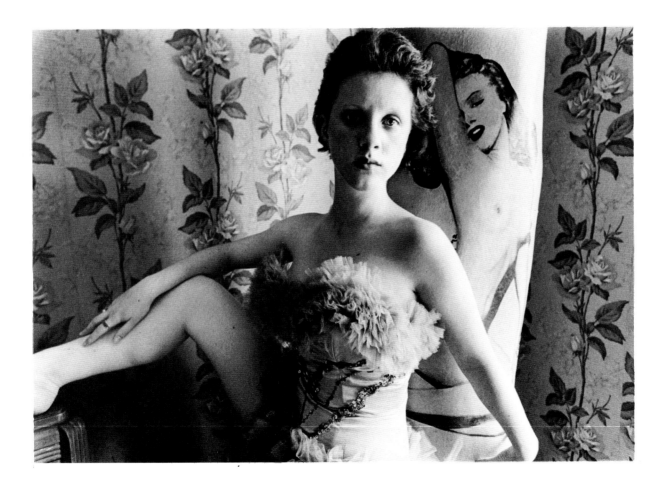

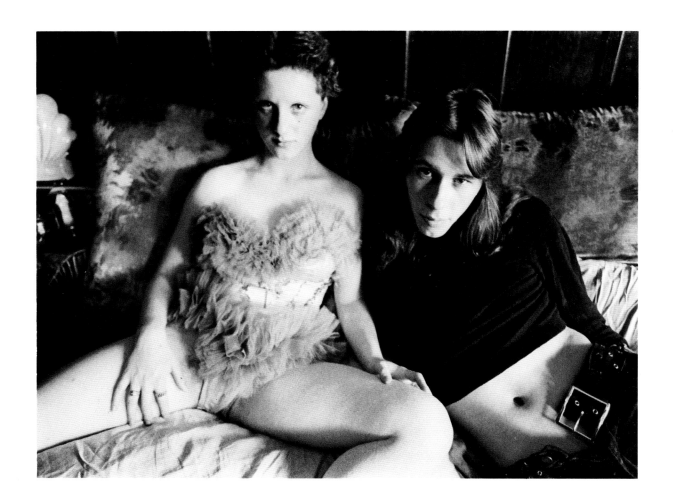

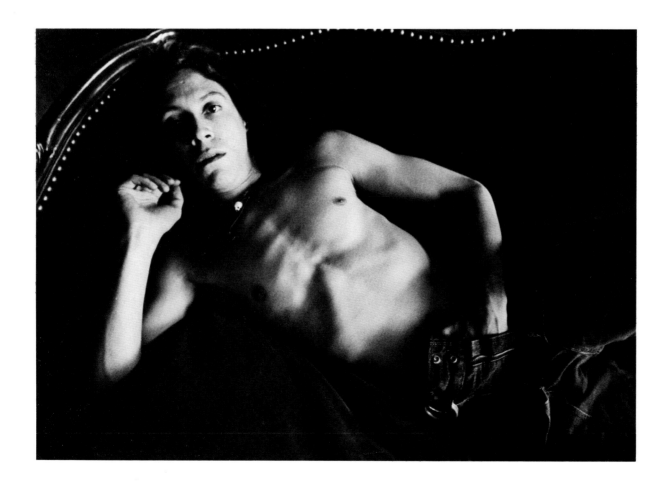

Edmund Shea

Born 1942, Medford, Massachusetts. Studied at Boston University and California State University, San Francisco. Exhibited at the Richmond Art Center (California), David Stuart Gallery (Los Angeles), de Saisset Gallery of the University of Santa Clara and the Light Gallery (New York City). Lives in San Francisco.

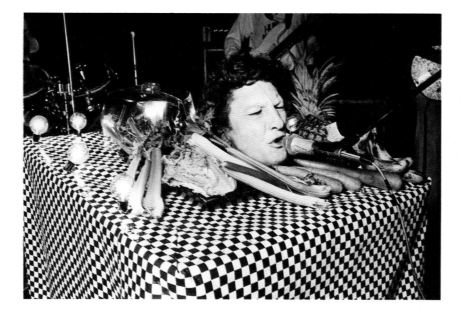

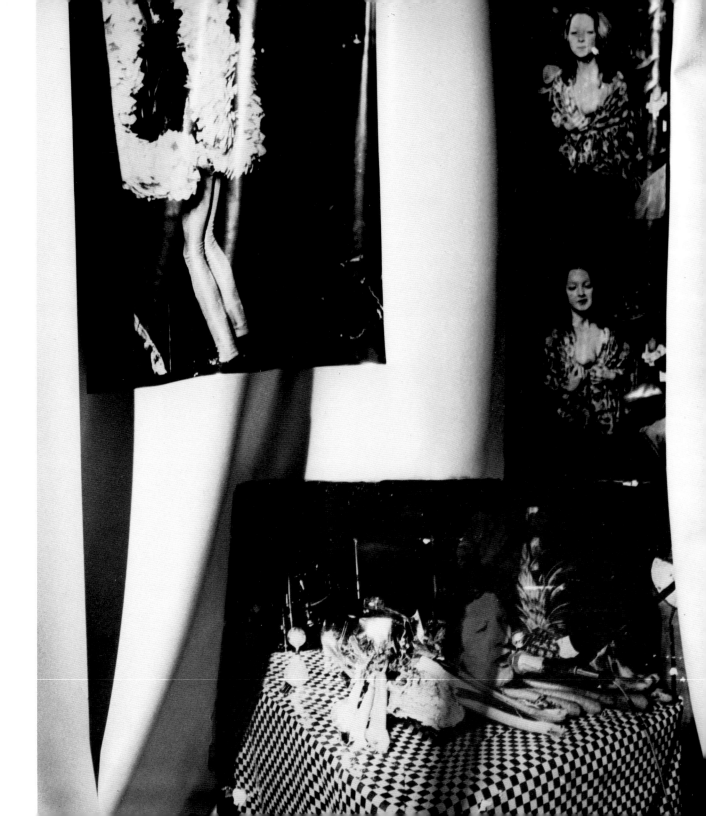

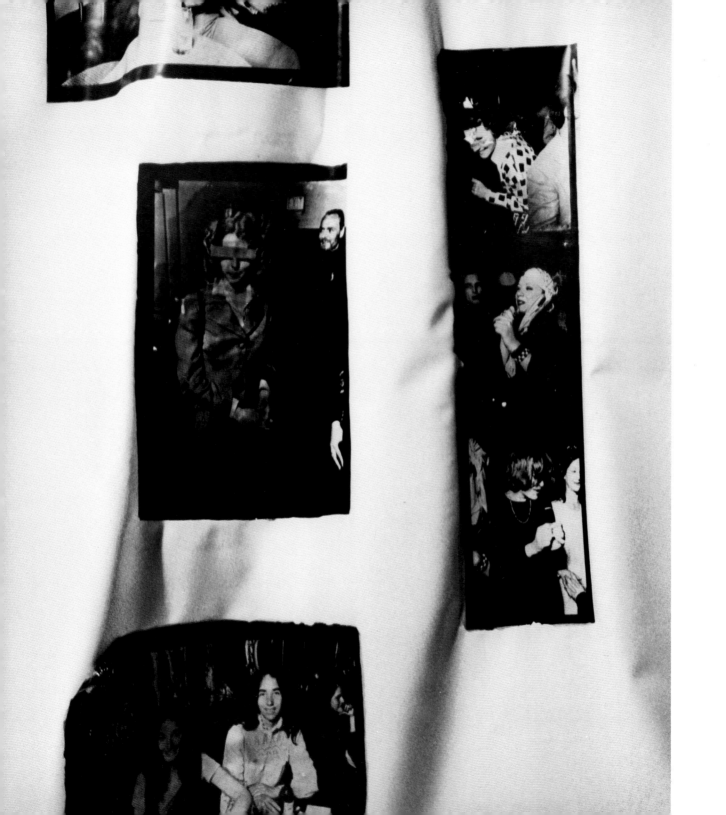

Steve Smith

Born 1943, Rochester, New York. Studied at the San Francisco Art Institute. Exhibited at Hampshire College (Amherst, Massachusetts) and the Addison Gallery of American Art, Phillips Academy (Andover, Massachusetts). Has taught at Hampshire College. Lives in San Francisco.

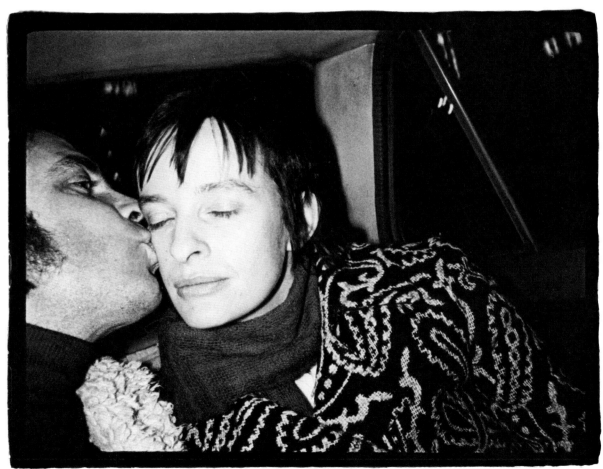

Me + Madeline Seoul Korea 1972 Steve Smith

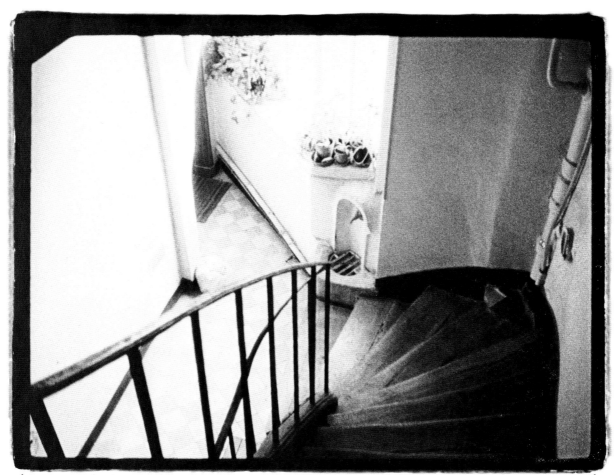

The stairs where I used to live in Paris Steve Smith

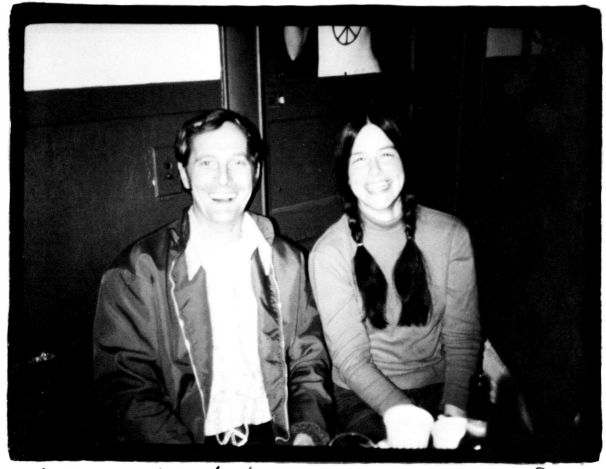

Luke & Katie at Hugo's 1973 Steve Smith

Gary Stewart

Born 1936, Minneapolis, Minnesota. Studied at the University of Minnesota and at the San Francisco Museum of Art.
Exhibited at the San Francisco Art Institute. Lives in San Francisco.

Gary Stewart

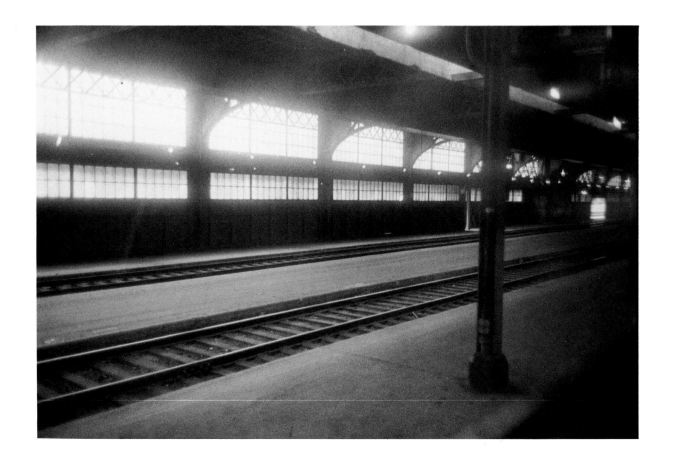

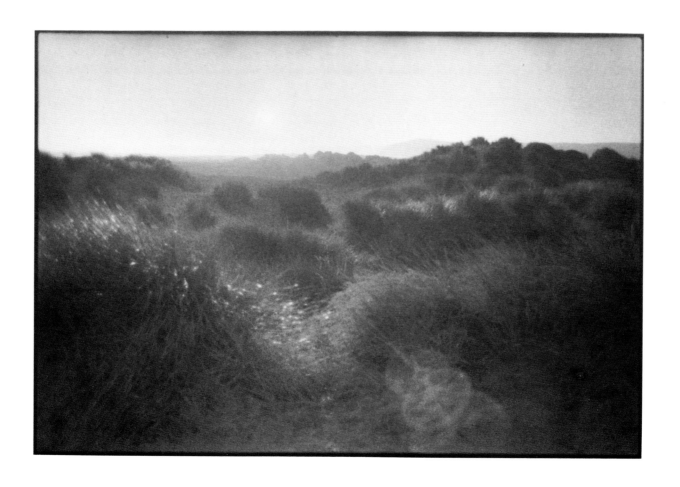

Lew Thomas

Born in San Francisco. Studied at the University of San Francisco. One-man exhibitions at the de Saisset Art Gallery of the University of Santa Clara (California) and the Alamo Gallery (Alamo, California). Lives in San Francisco.

"Jumping with Nikomat", 33" x 14", 1973

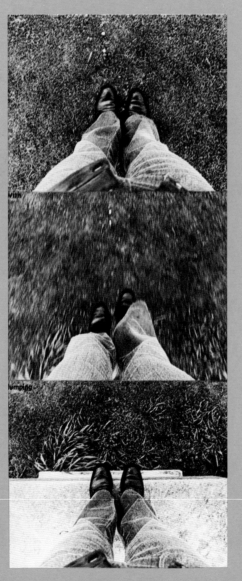

The pieces JUMPING WITH NIKOMAT and THROWING NIKOMAT depend on a direct causal connection between the camera photographing and the images photographed. Language is also used as a device to activate visual perception. I begin with the words throwing or jumping as a potential source of imagery. To express the actions of these three verbs will result merely in documentation and I wish to formulate an object that is purely photographic. At this point, the structure reveals itself when I attach the n-i-k-o-m-a-t to the process. In JUMPING WITH NIKOMAT, the camera is used as a participator in its own photograph. It is not only the cause of the pictorial content, it is the content. Though the camera is not seen, its motion and spatial differences are clearly manifisted in three part sequence. THROWING THE NIKOMAT is on one hand visualized by documentation, while at the same time, the camera is automatically exposing for one second the photograph of its own motion.................

A collage technique was introduced into my work to overcome the smooth surface usually associated with art photography and to explore a different kind of pictorial space. For some time I had been conscious of a wall I faced while watching television. The wall is made up of apertures such as a door, portrait, television set, closet, and mirror. By reproducing these apertures I expected to create an image deeper than one photographed from a single perspective. The wall was divided

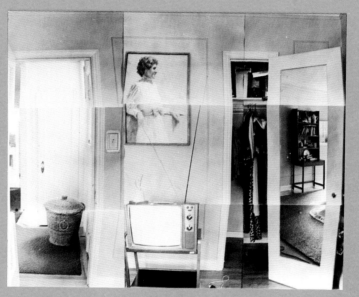

into an imaginary grid with nine spaces. Each space was photographed in a lateral sequence. When the photographs were ready for assembling, various kinds of single and double face masking tapes were used to piece the photographs together according to the grid. A loose, physical plane resulted from the seams and cuts encouraging the viewer to participate in the method of construction. The objects within the grid like the basket, television set, clothes in closet, or wiring on floor project scupturally from the spaces separating one from the other. The collage materials create one plane of trompe l'oeil effects over those immersed in the illsuionism of the objects and wall. This duality of content and materiality represents a dialogue between the photographic piece and photography. No other meaning is intended in the collage works except the description of an idea. "You're considered mad until your idea succeeds." MASASHI MATSUMOTO

GRASS represents the use of a field as a pictorial structure. A format is cre
ated by adapting the content of a roll of film to a flat surface. Unlike othe
r work involving a serial order and a linear scanning, this piec can be read w
holly. The fie 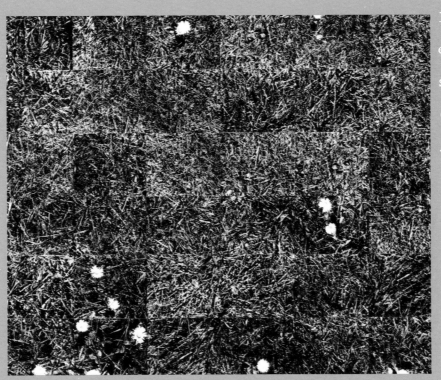 ld is ONE order,
a whole parcel even though the
pieces or print s meshed togethe
r are random ph otographs of the
same textures. An aerial vantag
e of six inches activates the p
oint-of-view th at leads to exe
cution. The wo rk is presented
as a wall piece that requires t
he viewer to fa ce a disorienta
tion of perspec tive. Though th
e piece has a f ixed setting, th
e wall, it can function in any direction, vertically or horizontally. The imag
e of grass is nothing more than a skin precisely fitted and stretched across th
e formal ideas of scale, linearity, randomness, elevation, setting, and order.
There are now logic and ideas in photography and individual photographs. Not j
ust things, or people, or decisive moments. There are other concomitants like
scale, materiality, anti-decisive moments, metaphor, and motion which are indep
endent of the classical elements of light, tone, expressiveness and likeness...
Robert Leverant, THE SNAPSHOT...